TURNTABLE TIMMY

Written by **Michael P.**
Illustrated by **Doug Cunningham**

First Gasp

For my Godchildren,
Shawn, Curtis, Ariel, and Benjamin.
Nino loves you. —M.P.

For my son Sean.
The world is yours. —D.C.

Text copyright © 2002, 2006 by Michael Perry
Illustrations copyright © 2002, 2006 by Doug Cunningham
All rights reserved. This book, or parts thereof, may not be
reproduced without permission in writing from the publisher.
Published by First Gasp, a children's book imprint of Last Gasp.
777 Florida St., San Francisco, CA 94110.

Printed in Hong Kong.

Book design by Doug Cunningham

Text is set in Bookman Old Style. The art for this book was
illustrated digitally. Music for the audio CD provided courtesy of
DJ QBert for Cat Breath Publishing (BMI) All rights reserved.
Freestyle rap on "Turn the Page" performed by Michael Perry.
Special thanks to: QBert, Yoga Frog, Disko Rick, Mr. Henshaw,
StarMira, Adisa Banjoko, Glo-Love, Jessica, Valiente "Turntable
Timmy" Montoya, Chris Montoya, and Stephanie Ervin. Good lookin' out.

Publisher's Cataloging-in-Publication
(Provided by Quality Books, Inc.)

Perry, Michael, 1966-
 Turntable Timmy / written by Michael Perry ;
illustrated by Doug Cunningham. -- 1st ed
 p. cm.
 SUMMARY: Timmy is determined to hip-hop his way to
becoming the world's youngest turntable champion. He
realizes that in order to achieve his dream, he must work
hard, practice and maintain his dedication.
 ISBN 0-86719-633-5

 1. Hip-hop--Social aspects--Juvenile fiction. 2. Rap
(Music)--Social aspects--Juvenile fiction. 3.
Phonograph turntables--Juvenile fiction. 4. Motivation
(Psychology)--Juvenile fiction. [1. Hip-hop--Fiction
2. Rap (Music)--Fiction. 3. Phonograph turntables--
Fiction. 4. Motivation (Psychology)--Fiction.
5. Stories in rhyme.] I. Doug Cunningham. II. Title

PZ8.3.P428Tu 2002
 [Fic]
 QBI33-450

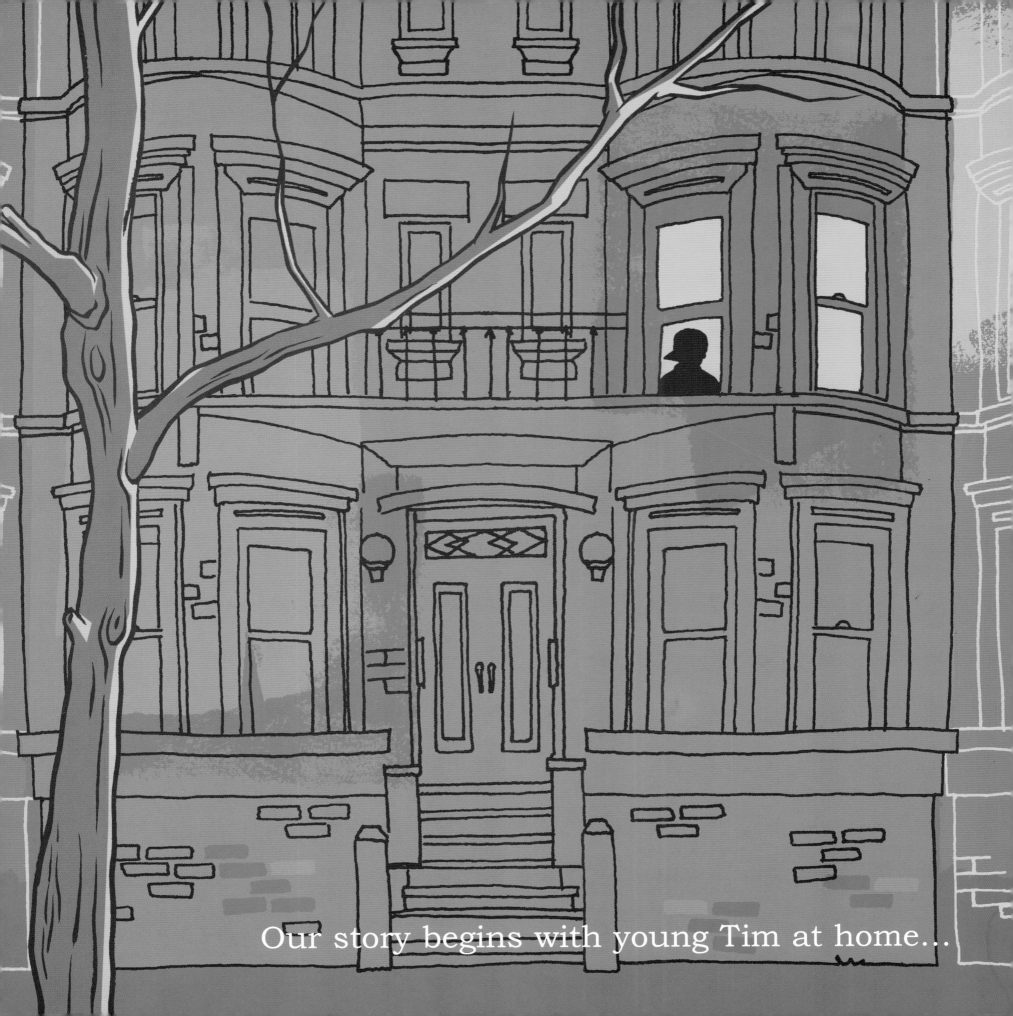

Our story begins with young Tim at home...

Wreckin' two turntables and a microphone.

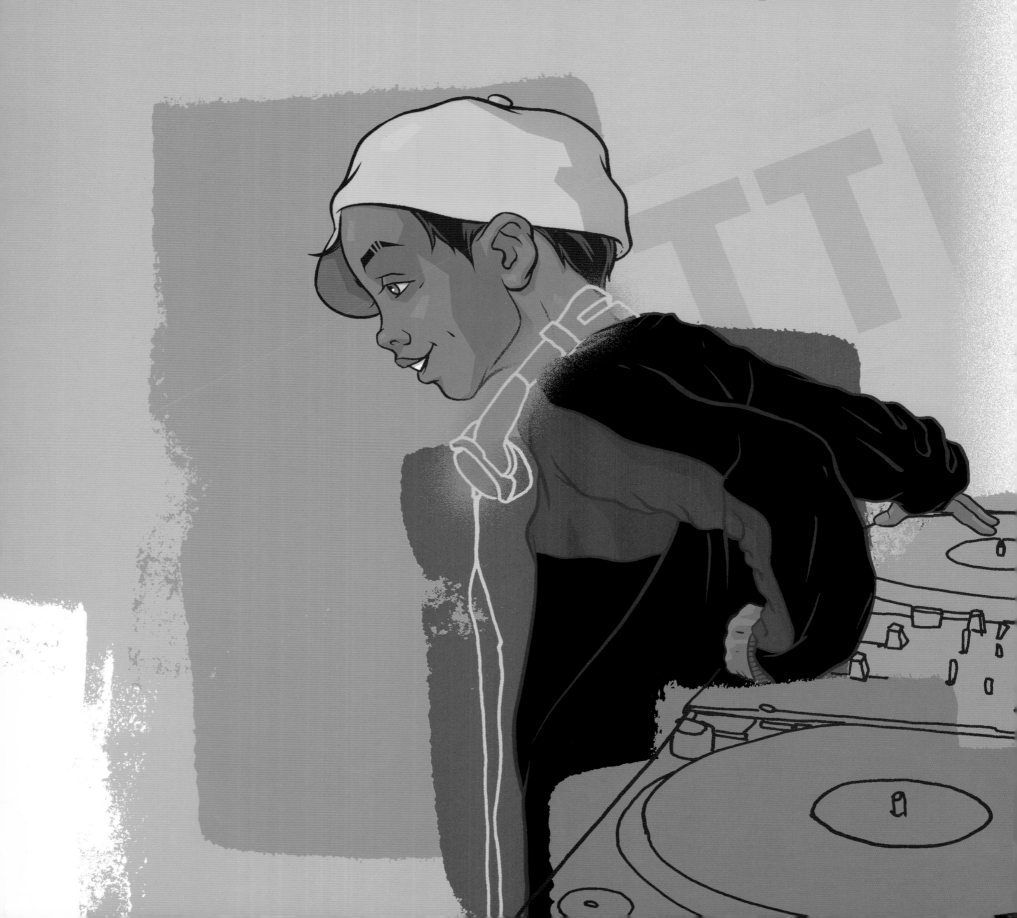

The mixer's in the middle,
music in the mix.
Side-to-side behind his back
cool deejay tricks.

He likes cuttin' and scratchin', scratchin' an

...ttin', break-dance, bugaloo, b-boy struttin'.

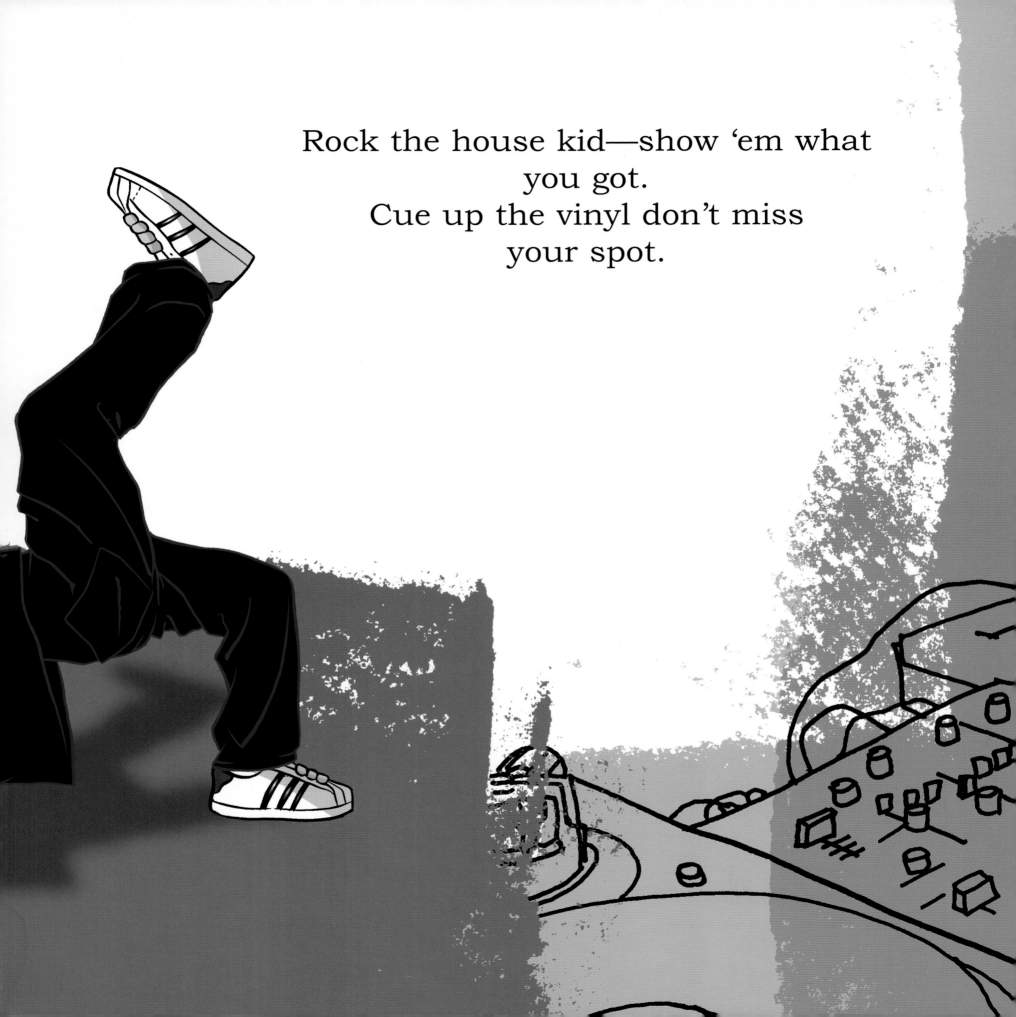

Rock the house kid—show 'em what
you got.
Cue up the vinyl don't miss
your spot.

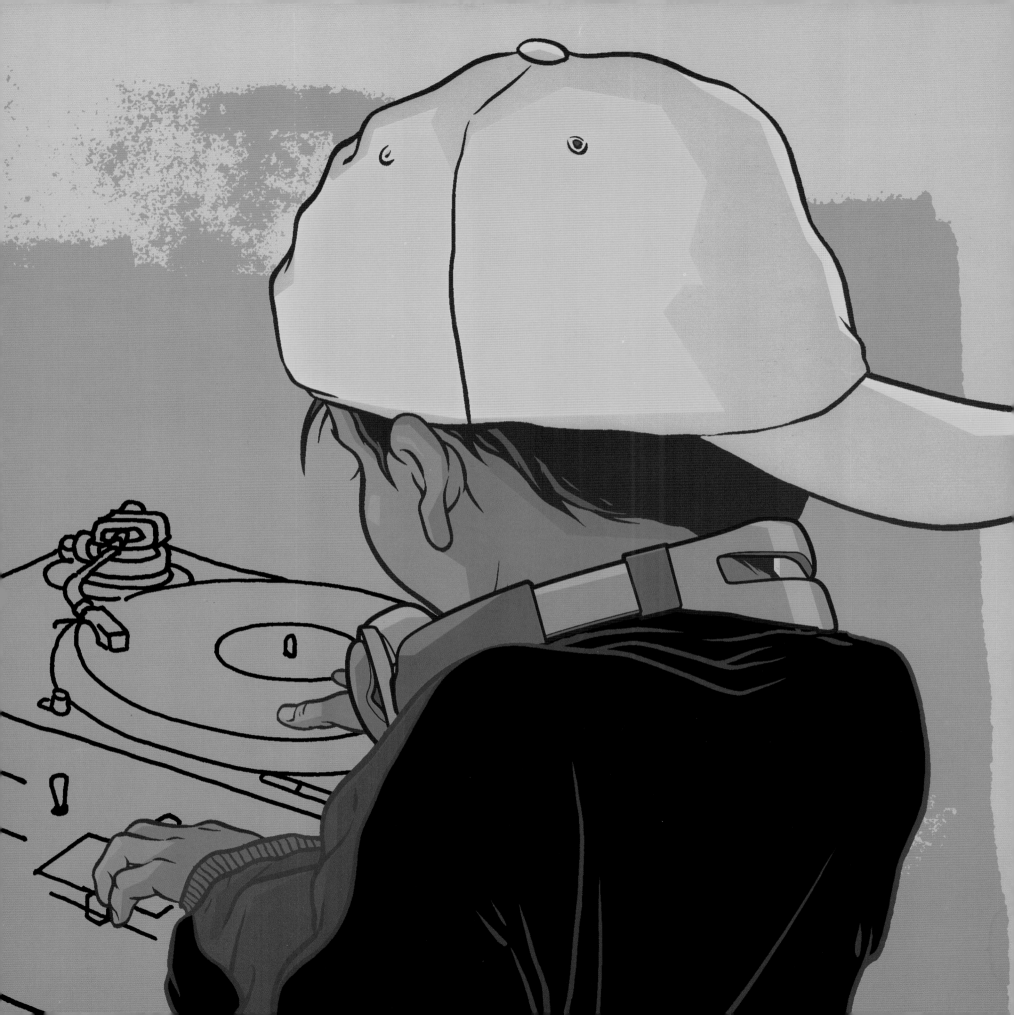

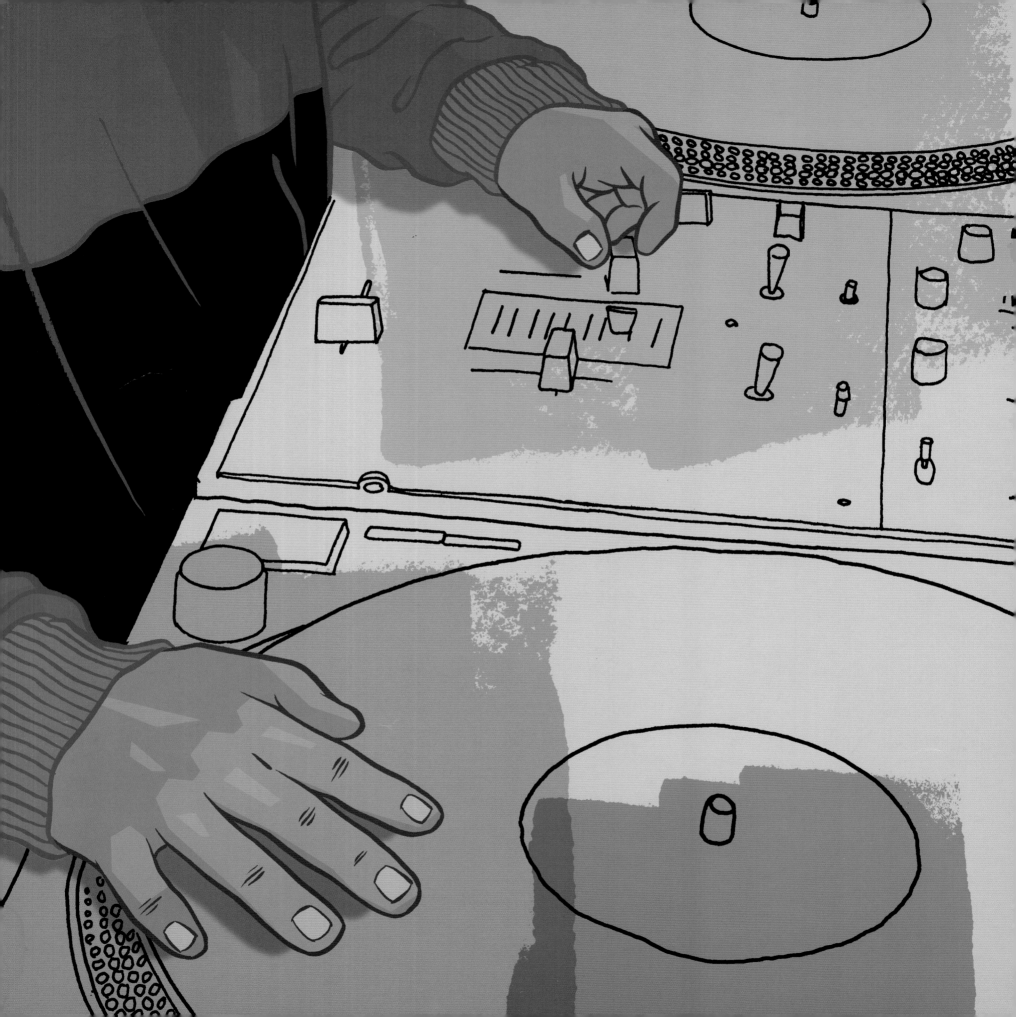

Let it go, pull it back,
don't let the needle jump.
Turn up the volume,
make the speakers bump.

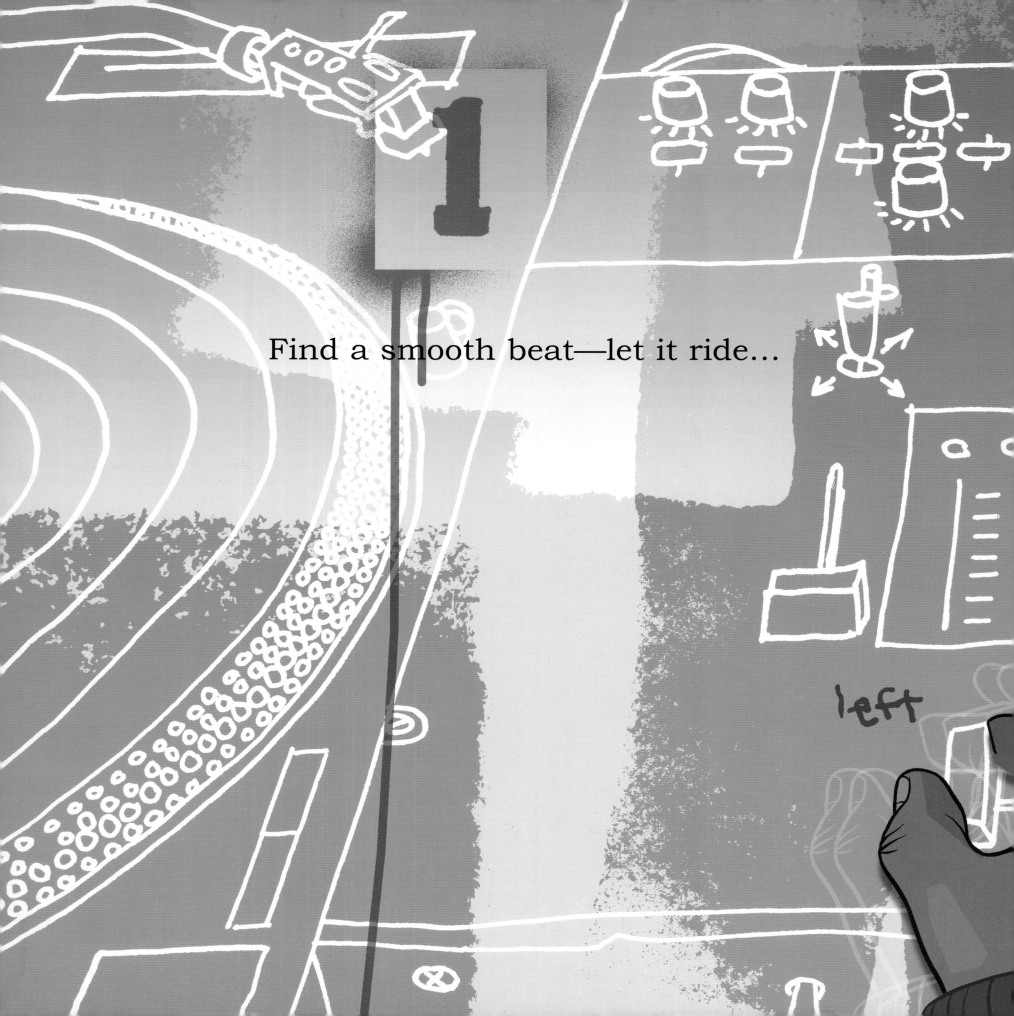

Find a smooth beat—let it ride...

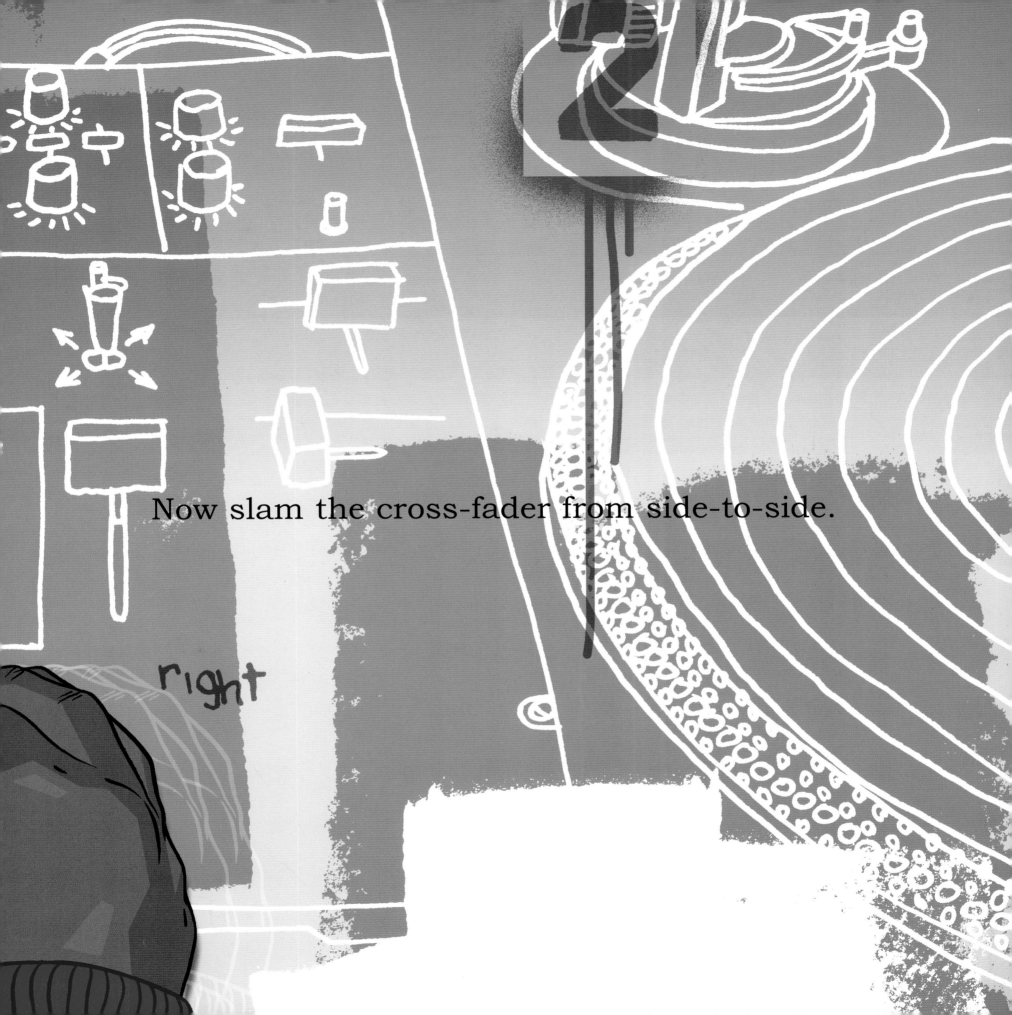

Now slam the cross-fader from side-to-side.

right

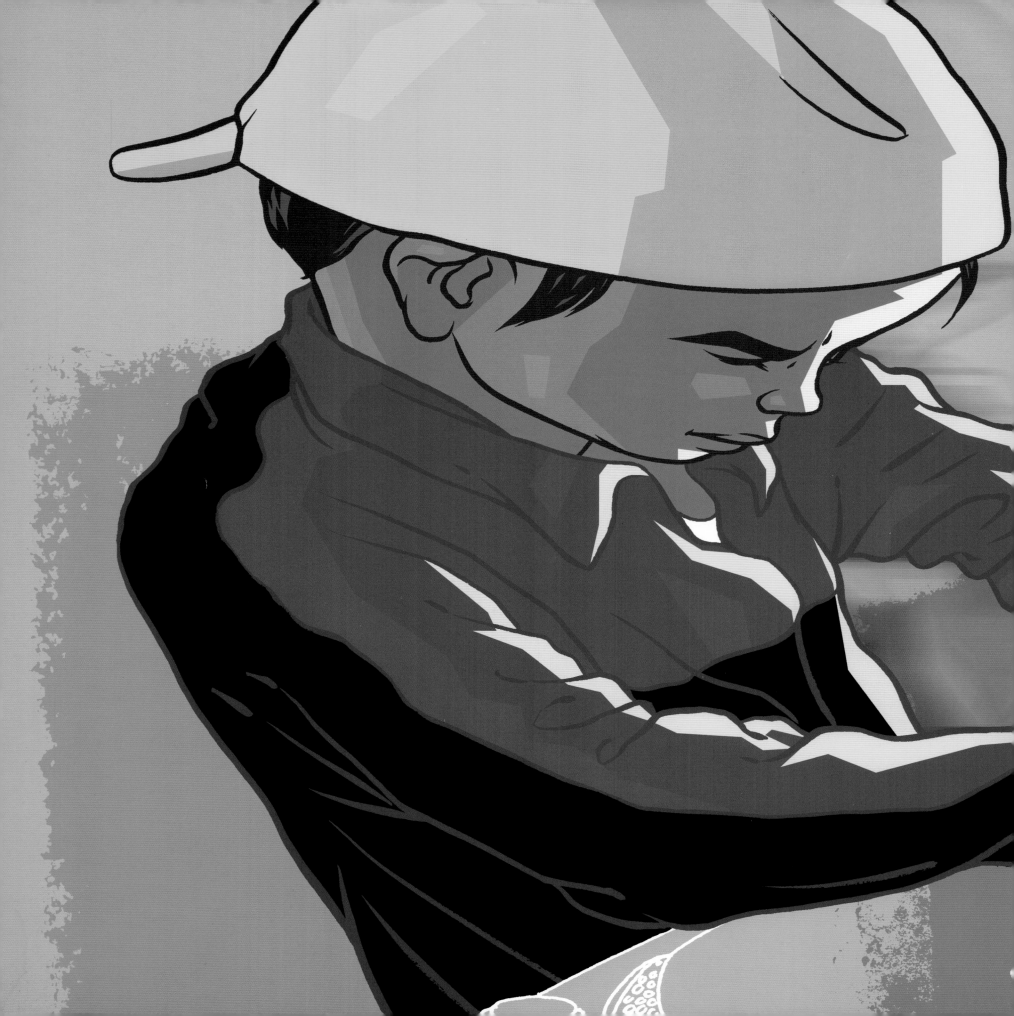

Cut the record back and forth like a lumberjack choppin',
flex your wrist with a twist, cool collar poppin'.
That's the good stuff...

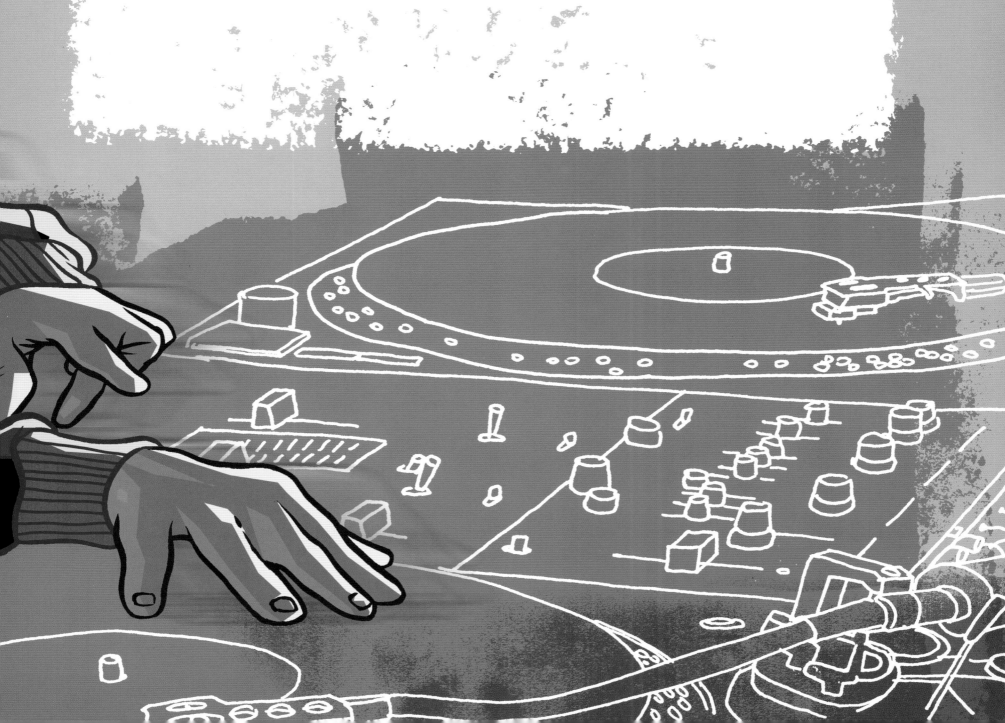

That fresh Hip-Hop.

My man be sweatin' beads y'all but he won't stop.

He has his eyes on the prize,
they twinkle and gleam.
Double-T on a mission to fulfill
his dream.

Only one deejay can be crowned
the king—
the greatest of all, top dawg
supreme.

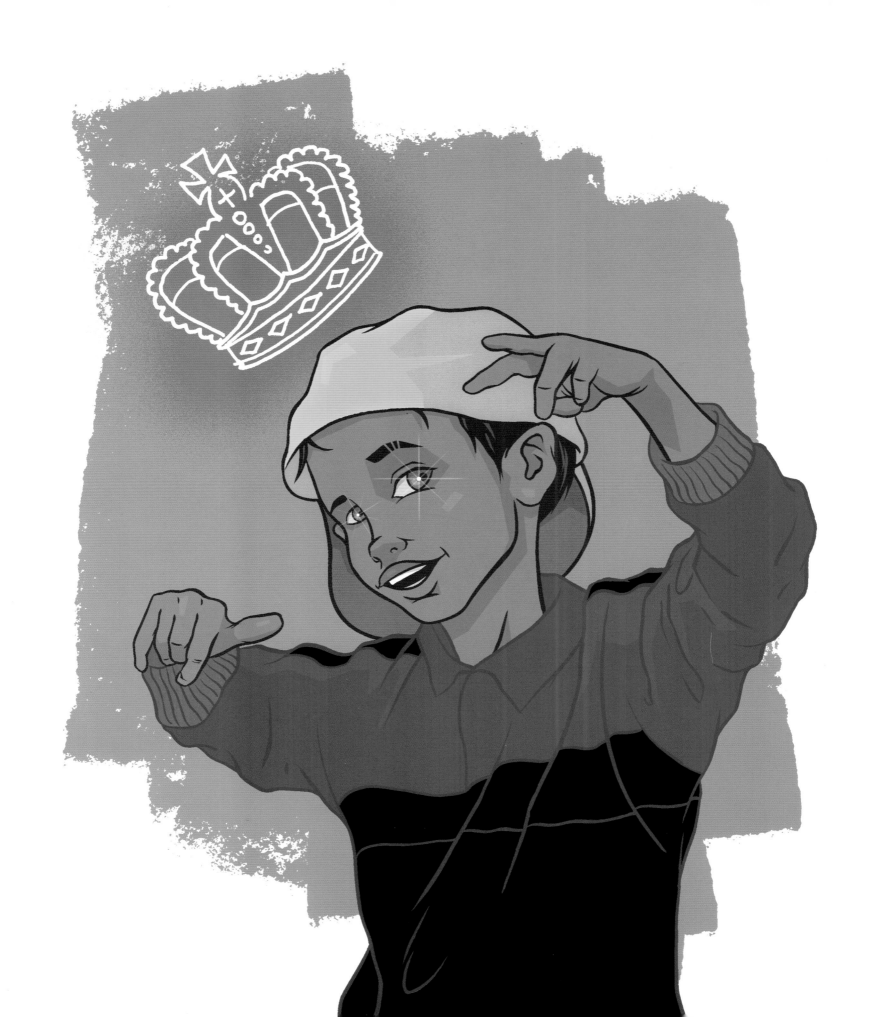

So he puts in work, day and night.
Practice makes perfect, gotta get it right.

Hard work and dedication—perfection
takes practice,
now he's quick like a fox, sharp
as a cactus.

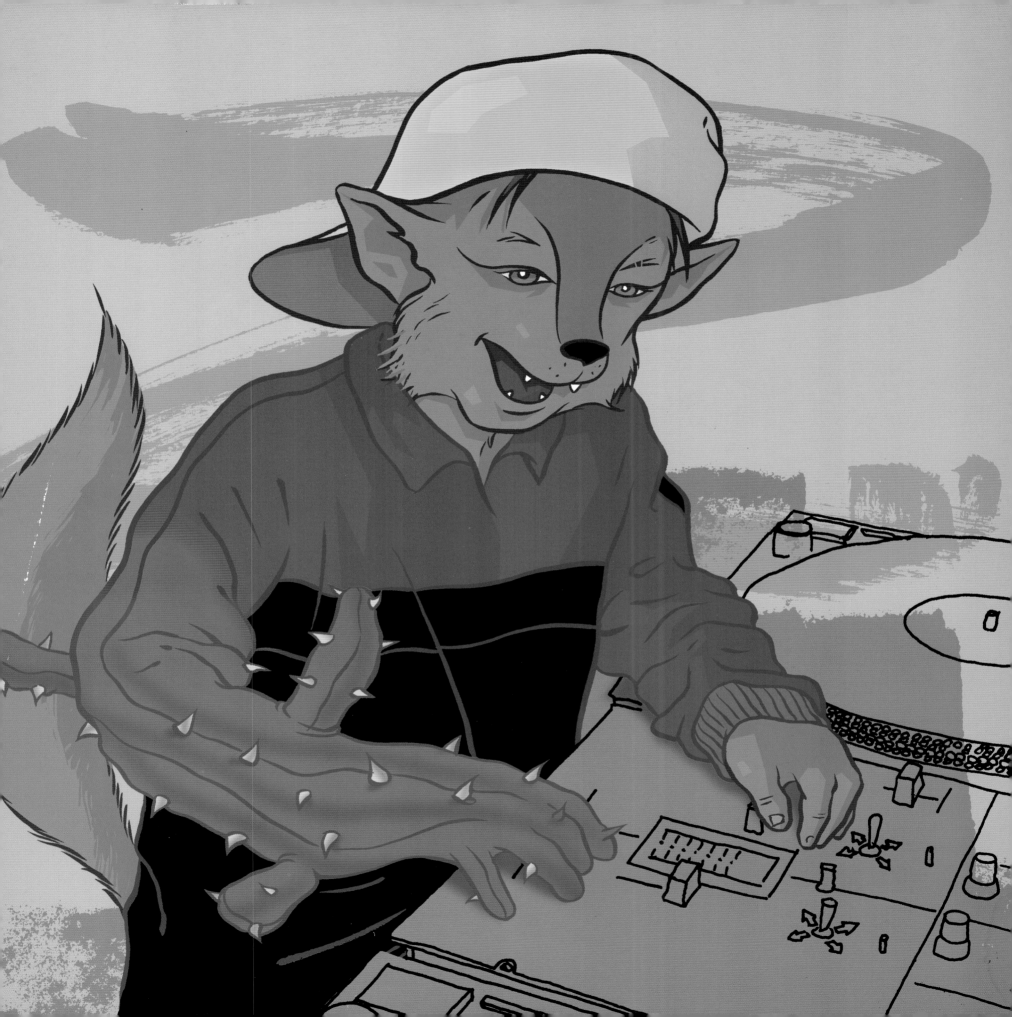

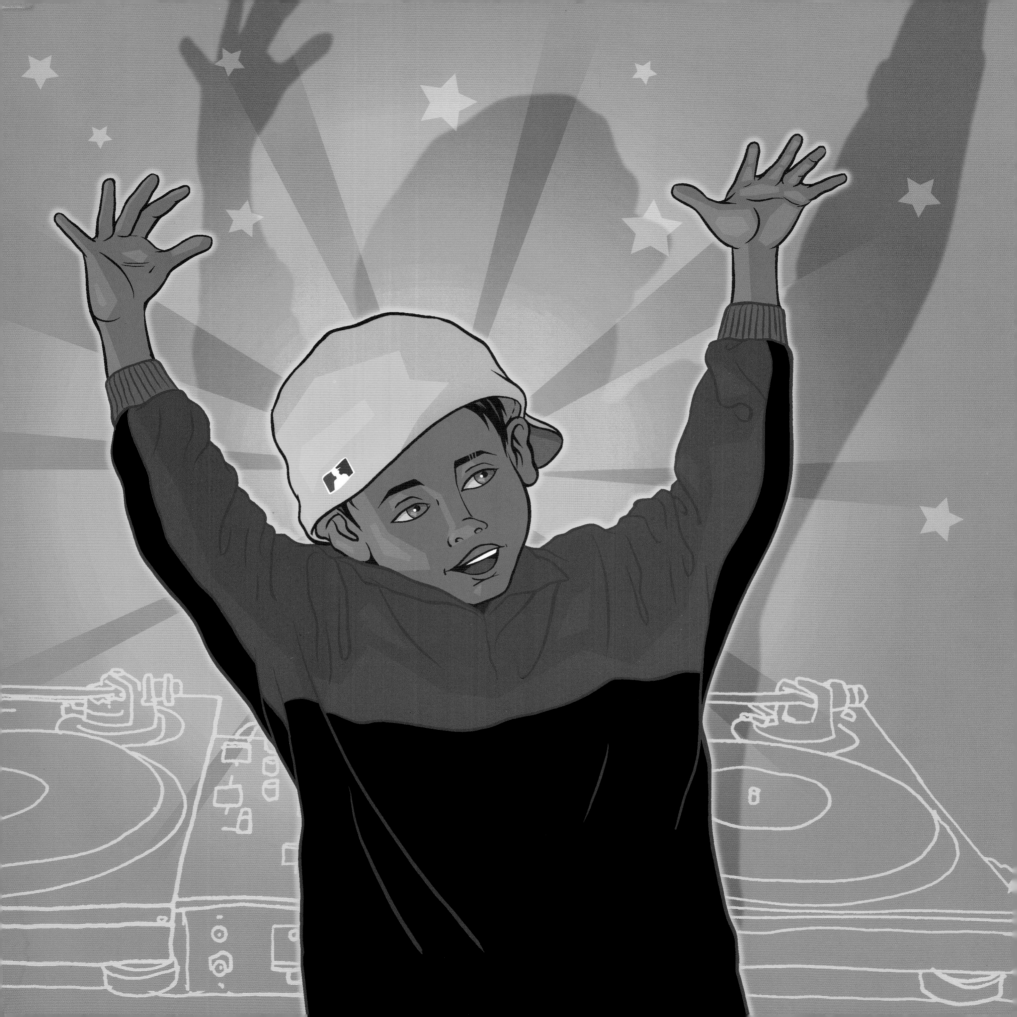

Bright as the sun
on a hot summer day,
just throw your hands in the
air and let your backbone
sway.

And just clap your
hands if you feel this—
and if you're feelin' this
clap your hands.
The future looks bright
for Tim y'all, because
he has big plans.

He's got the Midas touch,
hands of gold.
Developed mad skills at
two years old.

Now he's eight, soon to be nine.
Believe and you'll achieve, just let
the stars shine.

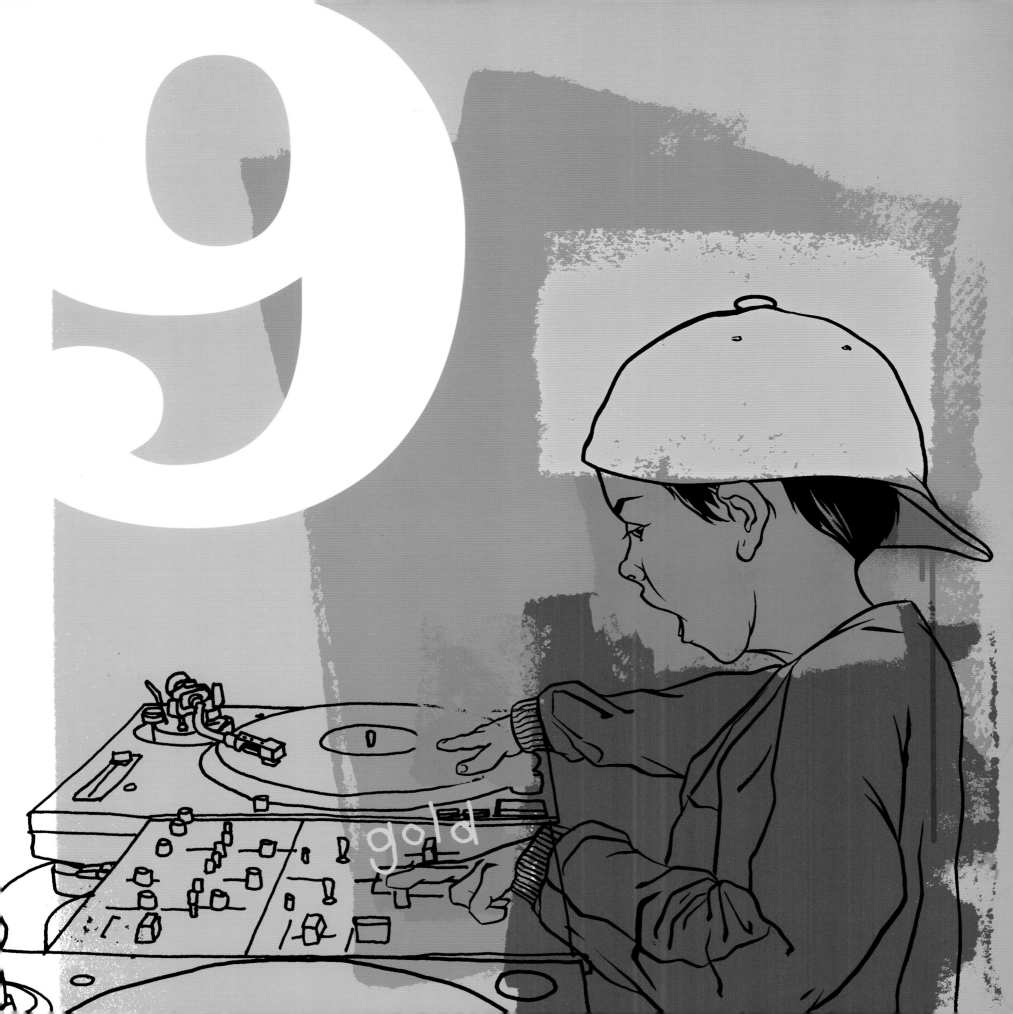

Everybody has a talent on
this earth,
and you can take it or leave it for
what it's worth.

But if you set your mind to it,
you will succeed. Devotion is the
only tool you'll need.

A commitment to excel in all
endeavors, just like Tim when
he's on the levers.

Be true to yourself and always
come correct. Conduct yourself
with respect.

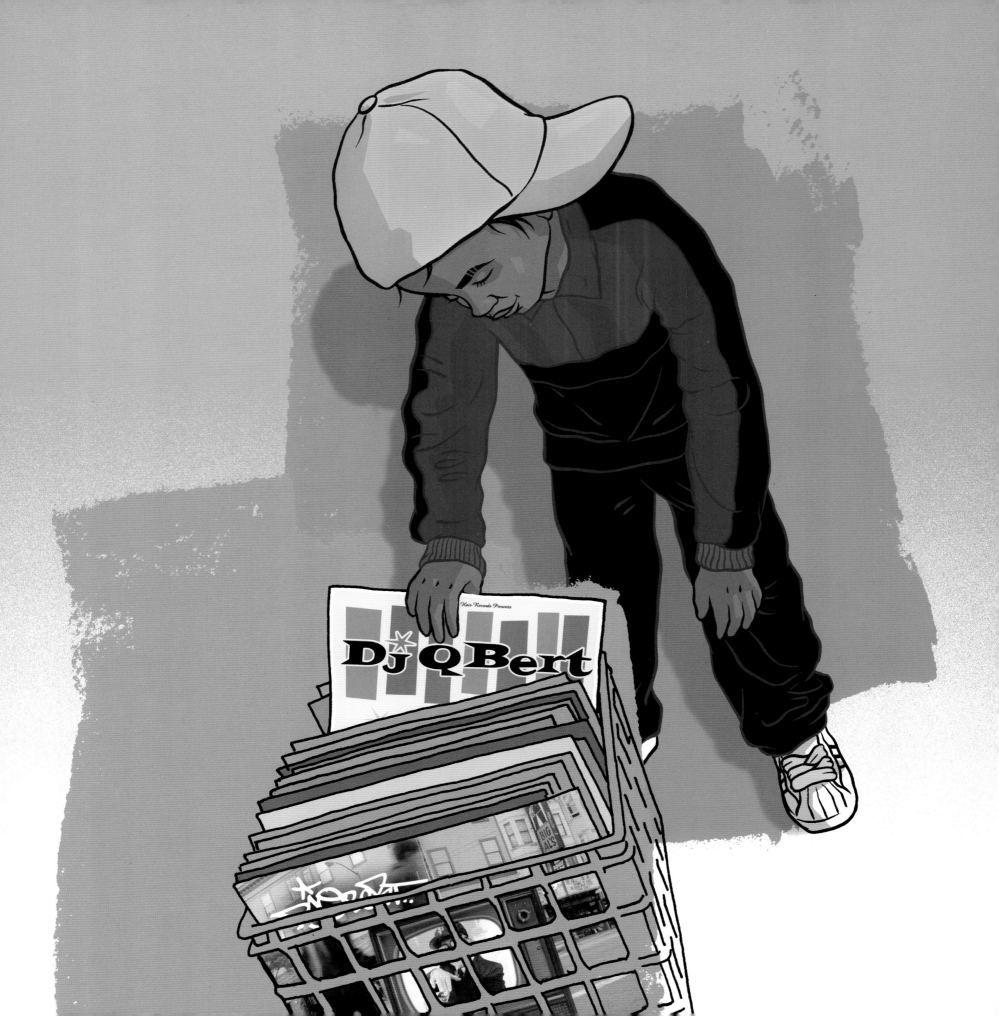

Young Tim, bring the noise,
put a smile on the face of all the
girls and boys.

Make 'em boogie down,
scream and shout.

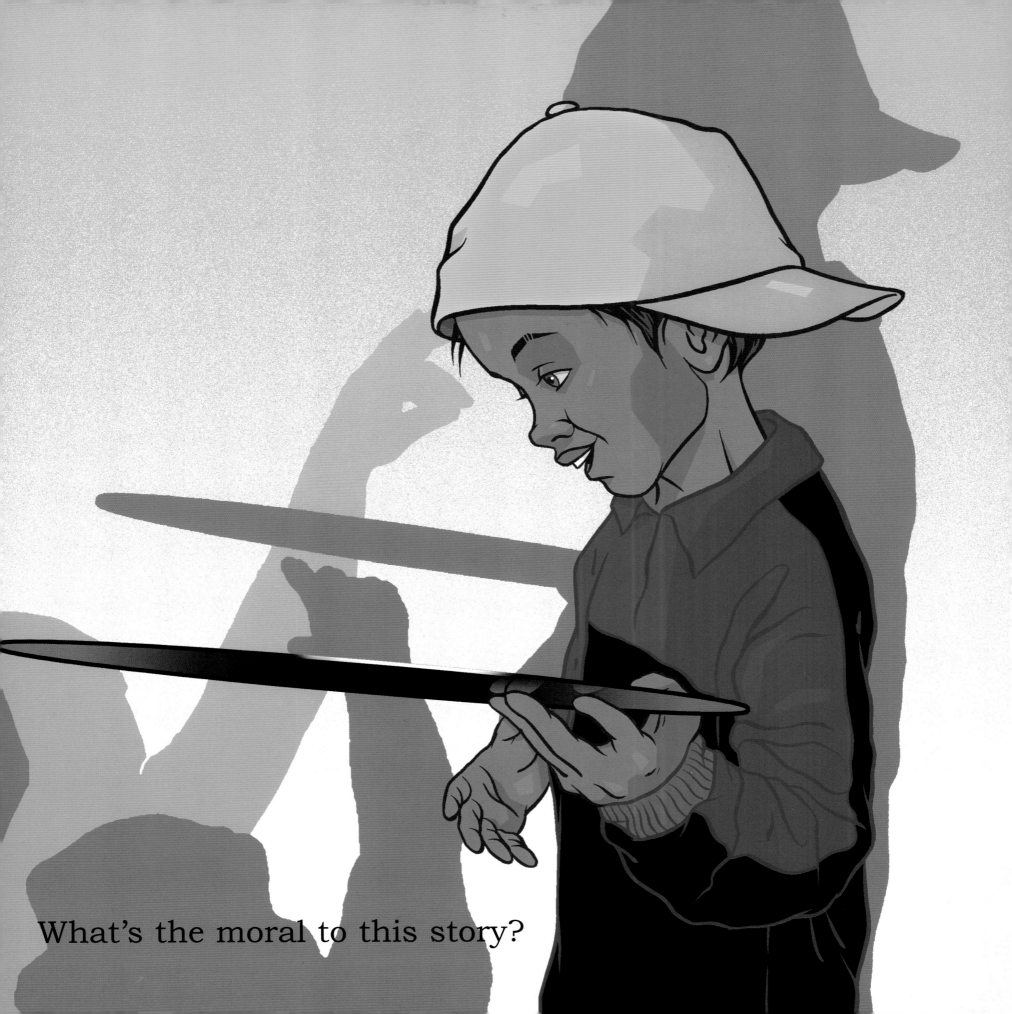

What's the moral to this story?

You figure it out!

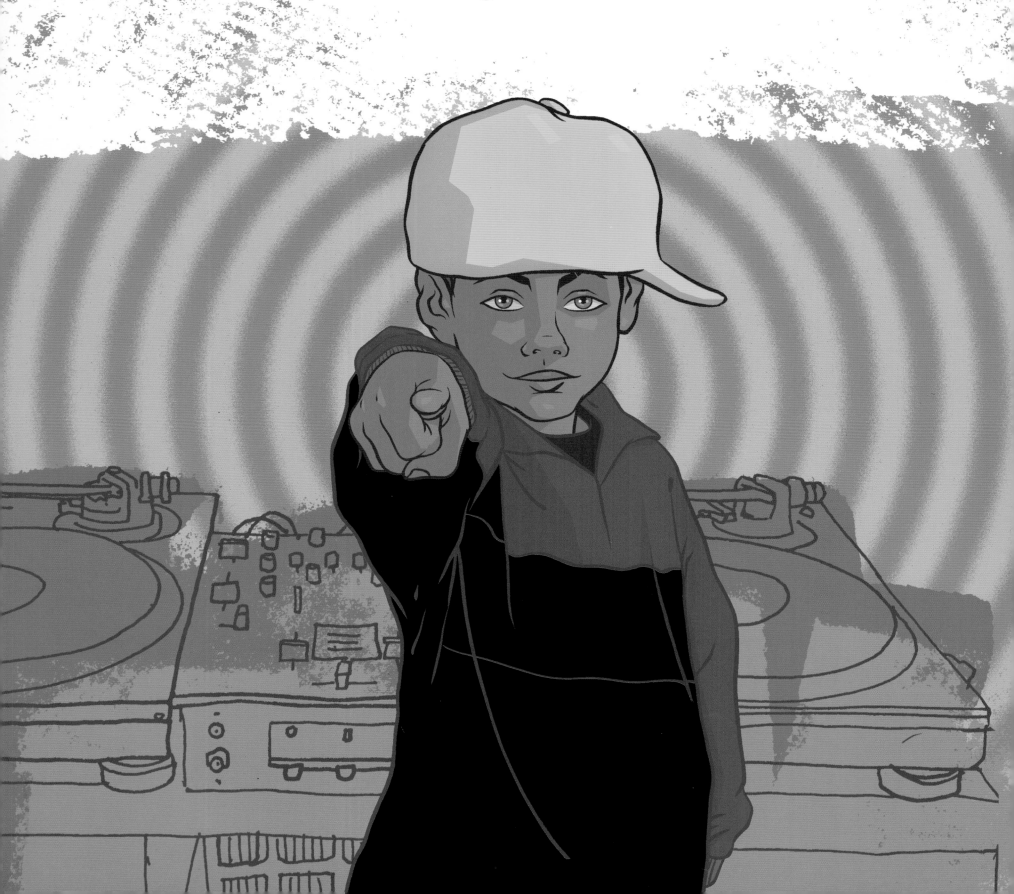